ORCHIDS

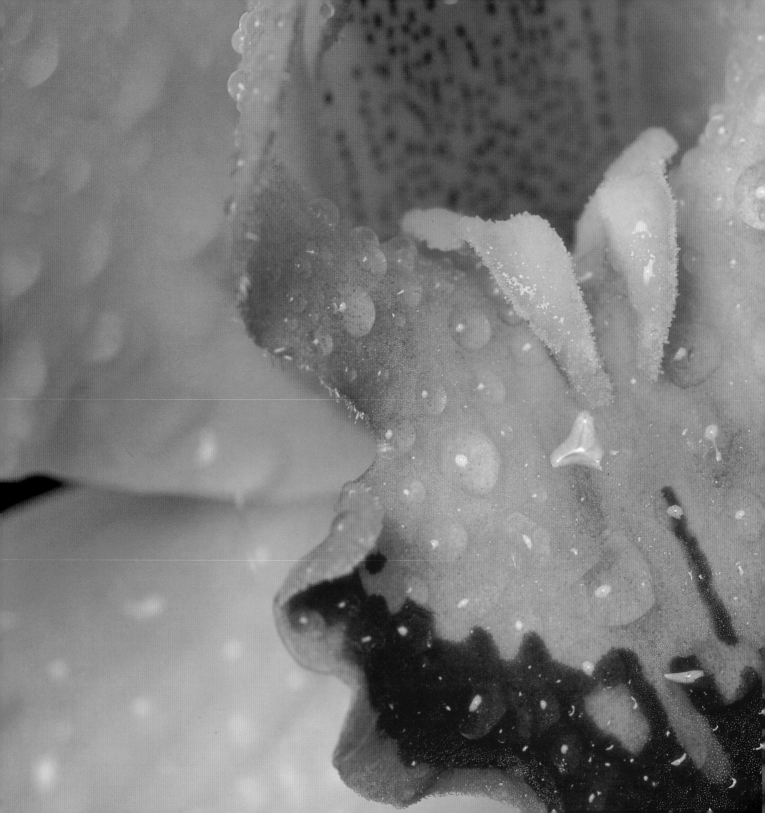

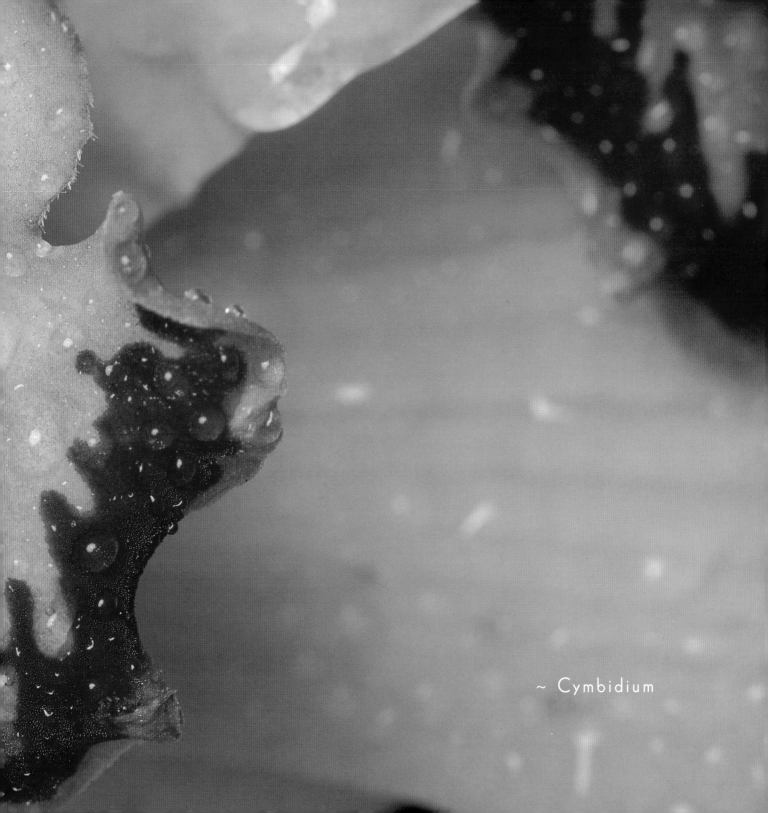

~ Cymbidium

ORCHIDS

~ Photography by Bruce Curtis ~

RP|CLASSICS
PHILADELPHIA · LONDON

9 8 7 6 5 4 3
Digit on the right indicates the number of this printing

Library of Congress Control Number: 2005626277

ISBN 978-0-7624-2456-6

Cover and interior design by Joshua McDonnell
Edited by Jennifer Leczkowski
Typography: Kabel, Schneidler Initials, & MrsEavesRoman

This book may be ordered by mail from the publisher.
But try your bookstore first!

Running Press Book Publishers
2300 Chestnut Street
Philadelphia, Pennsylvania 19103-4371

Visit us on the web!
www.runningpress.com

Contents

introduction

~ Cymbidium

Exotic. Fascinating. Sensual. Mysterious. The allure of the orchid is undeniable~from early explorers journeying into remote, tropical jungles in search of new and captivating species, to the millions of orchid enthusiasts and hobbyists around the globe today. With more than 30,000 species worldwide and more than 100,000 hybrids, no other group of flowering plants can compare to the astonishing diversity found within the orchid family. Their vast array of shapes, sizes, proportions, and colors continue to enchant collectors and cultivators, who have been able to grow them easier and less expensively than ever before with the help of new technology.

Inside these pages you will discover the exceedingly varied faces of this fabulous flower, illustrated through gorgeous full-color photography. Each glorious image showcases the unique beauty of this coveted blossom, capturing the nuances of each variety with brilliant color and style. Each stunning orchid is accompanied by its identifying genus name, highlighted by a thoughtful quotation that is sure to lift the spirits. *Orchids* will amaze and delight you, and perhaps even inspire you to start a collection of your own.

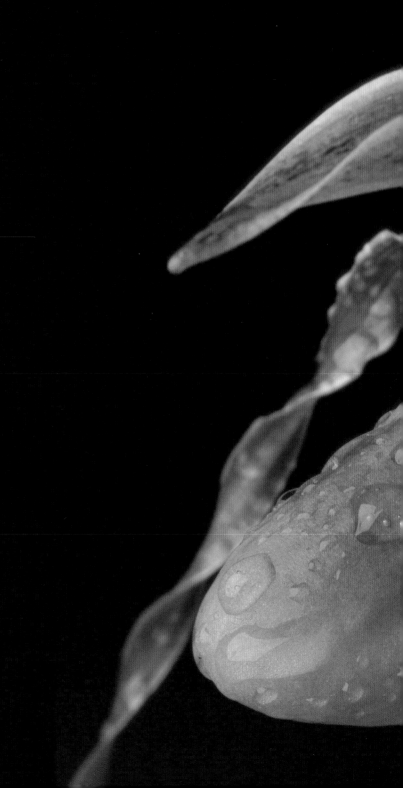

~ Phragmipedium

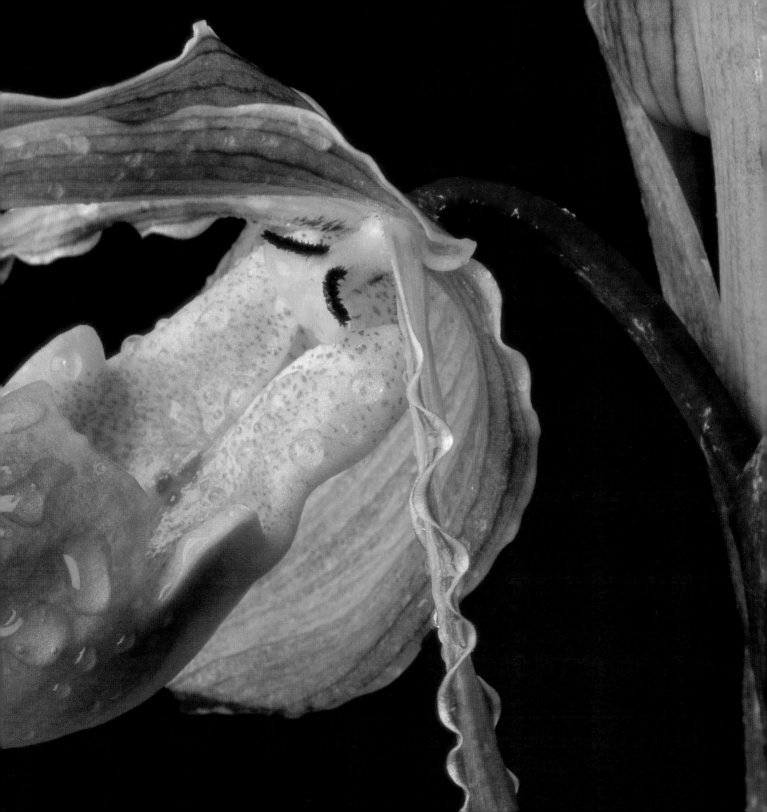

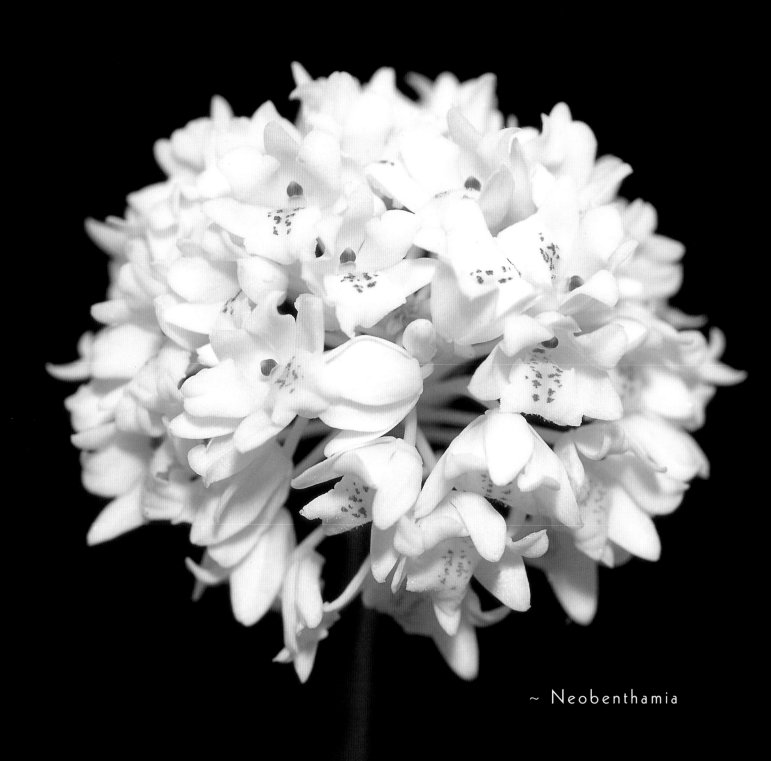

~ Neobenthamia

flowers

The flower is the poetry of reproduction.

It is an example of the eternal seductiveness of life.

~Jean Giraudoux (1882–1944)
French novelist and dramatist

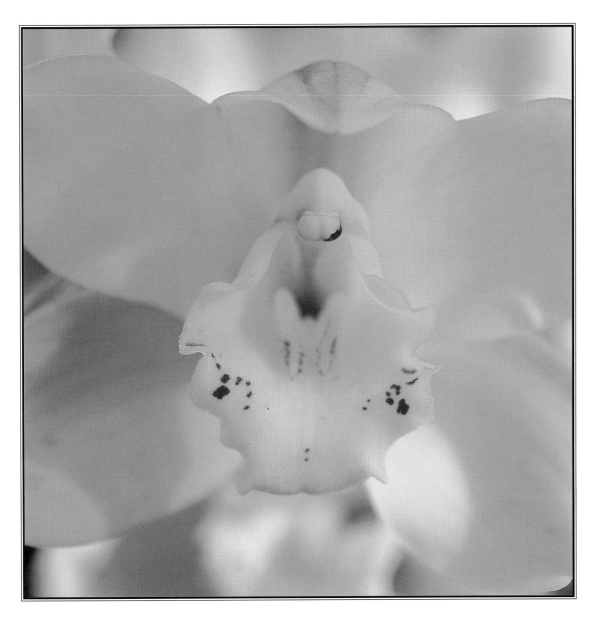

~ Cymbidium ~

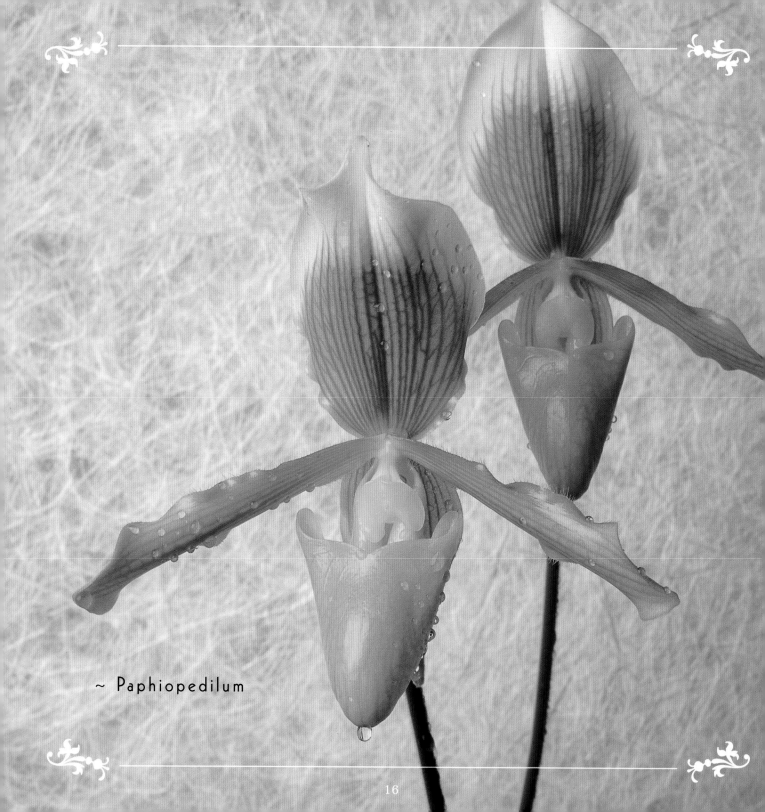

~ Paphiopedilum

Flowers seem intended for the solace
of ordinary humanity.

~John Ruskin (1819–1900)
English critic, artist, and writer

And 'tis my faith that every flower
Enjoys the air it breathes.

~William Wordsworth (1770–1850)
English poet

Give me odorous at sunrise

a garden of beautiful flowers

where I can walk undisturbed.

~Walt Whitman (1819–1892)
American poet

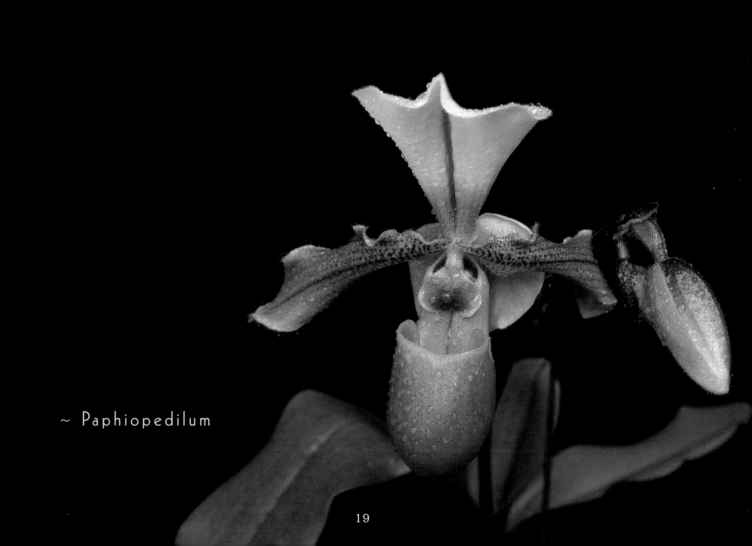

~ Paphiopedilum

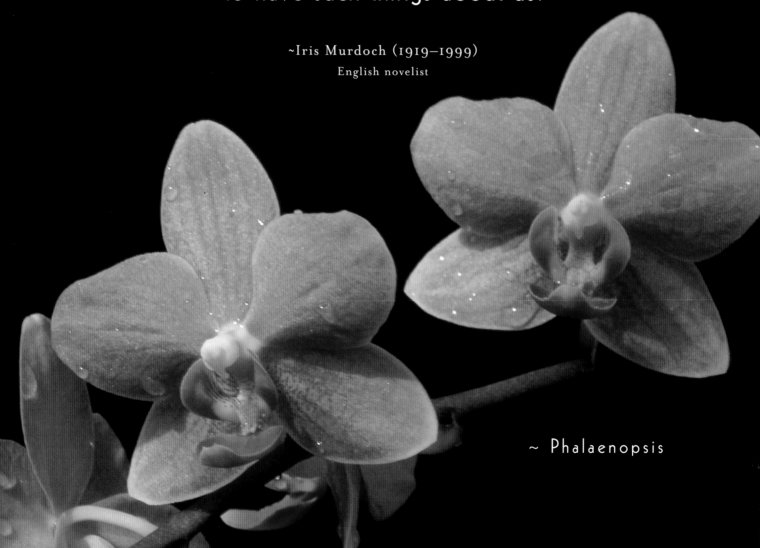

People from a planet without flowers would
think we must be mad with joy the whole time
to have such things about us.

~Iris Murdoch (1919–1999)
English novelist

~ Phalaenopsis

Flowers are love's truest language.

~Park Benjamin (1809–1864)
American journalist and poet

Each flower is a soul opening out to nature.

~Gerald De Nerval (1808–1855)

French romantic poet

Colors are the smiles of nature . . .

they are her laughs, as in flowers.

~Leigh Hunt (1784–1859)

English writer

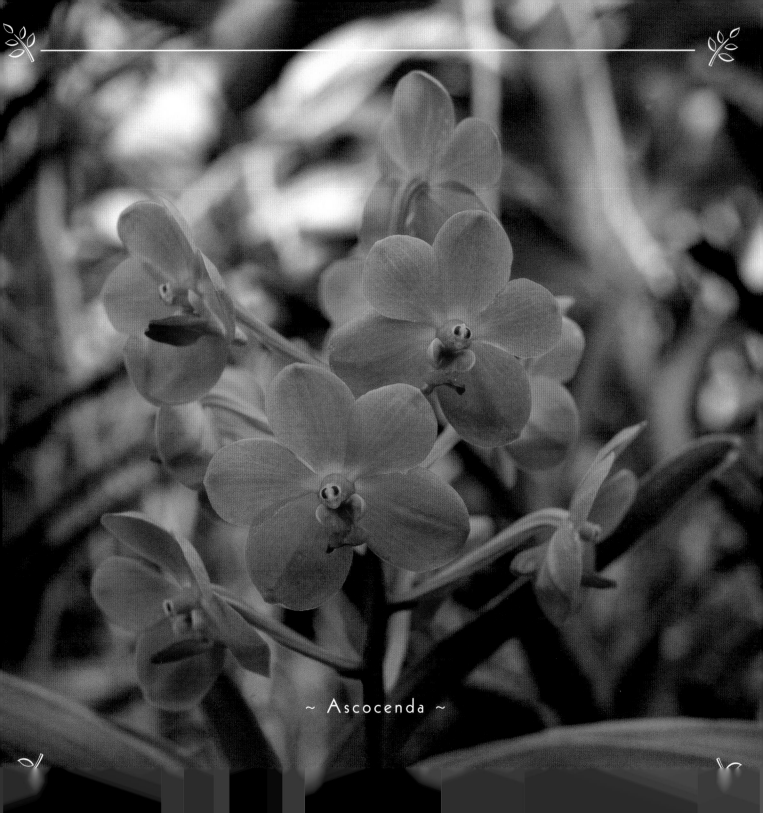

~ Ascocenda ~

~ Paphiopedilum

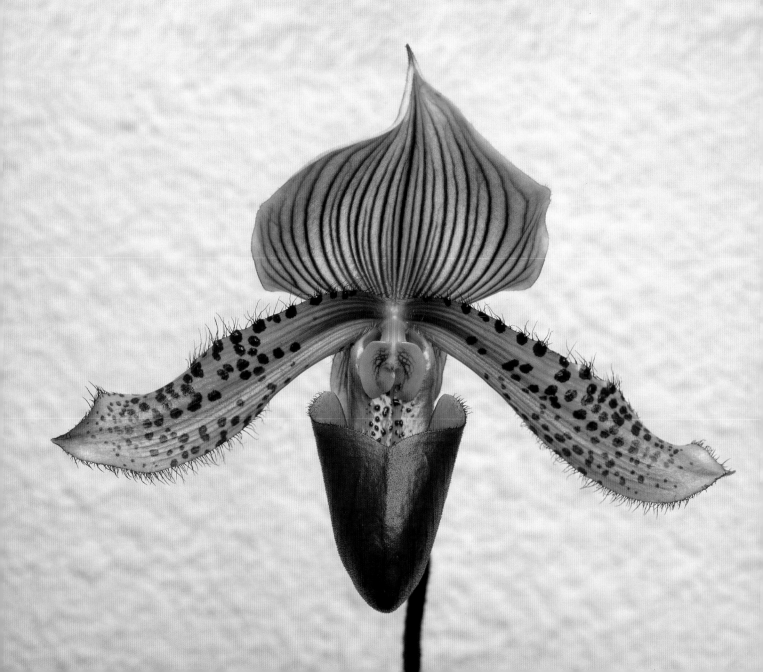

Flowers are restful to look at.

They have neither emotions nor conflicts.

~Sigmund Freud (1856–1939)
Austrian psychiatrist, founder of psychoanalysis

Flowers and plants are silent presences;

they nourish every sense except the ear.

~May Sarton (1912–1995)
Belgian-born American writer

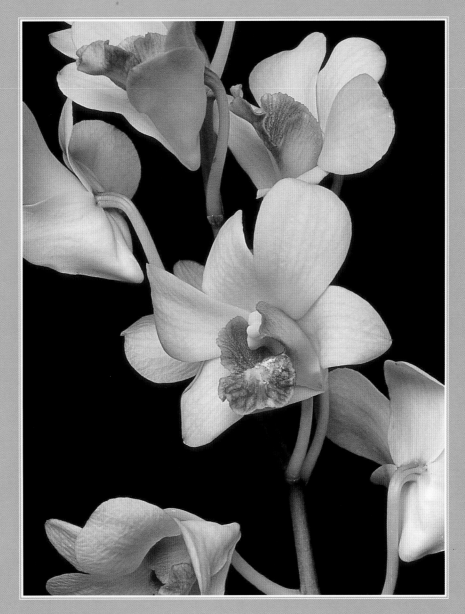

~ Cymbidium ~

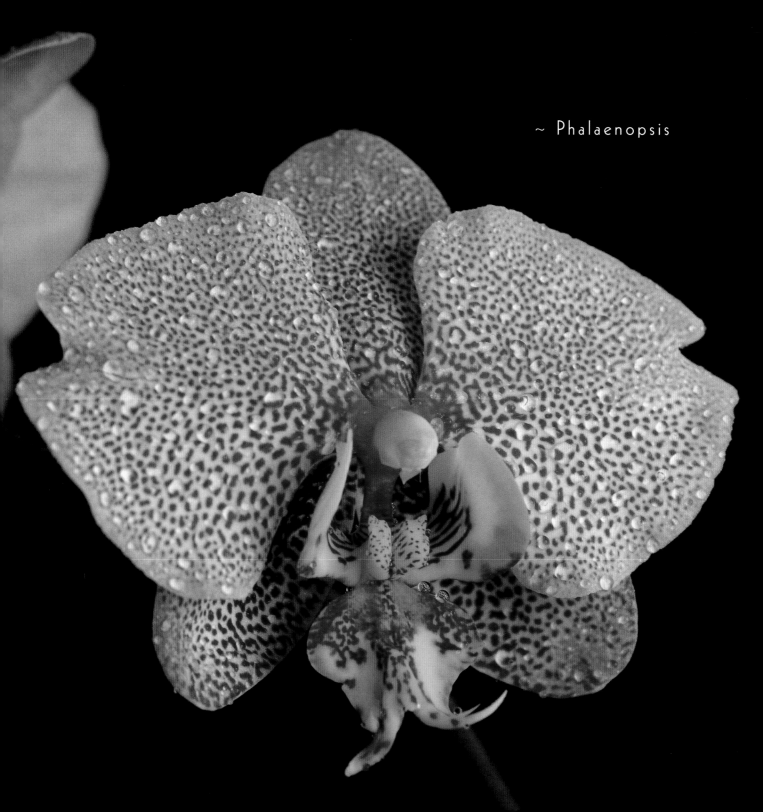

~ Phalaenopsis

growth

All growth is a leap in the dark, a spontaneous, unpremeditated act without benefit of experience.

~Henry Miller (1891–1980)
American writer

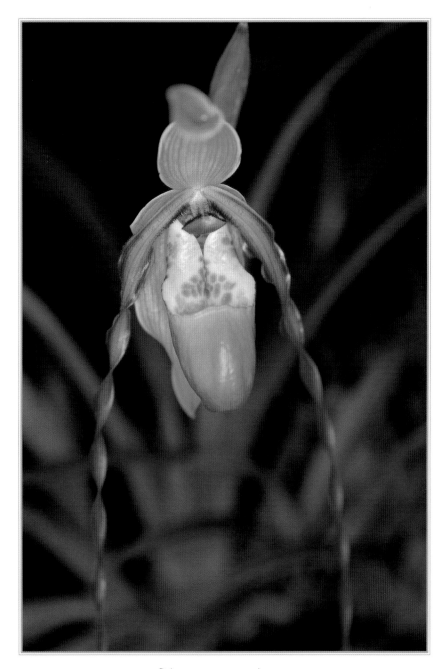

~ Phragmipedium ~

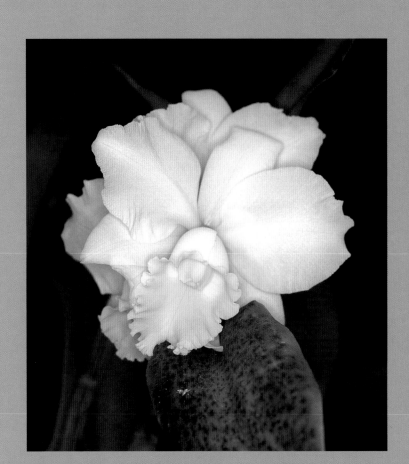

~ Cattleya ~

To exist is to change, to change is to mature, to mature is to go on creating oneself endlessly.

~Henri Bergson (1859–1941)
French philosopher

No person is your friend who demands your silence, or denies your right to grow.

~Alice Walker (b. 1944)
American novelist and poet

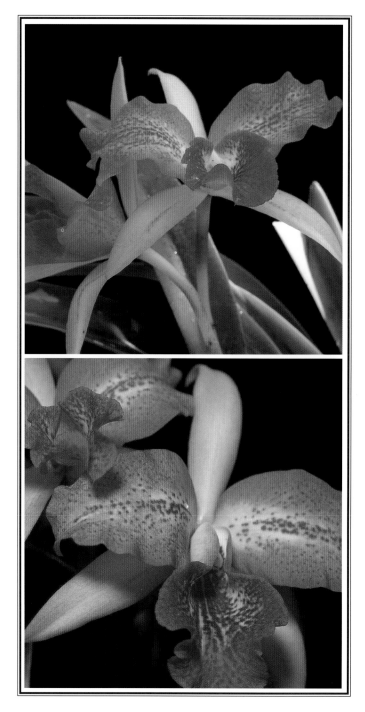

~ Cattleya ~

There came a time when the risk to remain
tight in the bud was more painful than
the risk it took to blossom.

~Anais Nin (1903–1977)
French-born American author

I am always doing that which I can not do,
in order that I may learn how to do it.

~Pablo Picasso (1881–1973)
Spanish painter

There are no such things as limits to growth, because there are no limits to the human capacity for intelligence, imagination, and wonder.

~Ronald Reagan (1911–2004)
American president

People grow through experience if they meet life honestly and courageously. This is how character is built.

~Eleanor Roosevelt (1844–1962)
American humanitarian and first lady

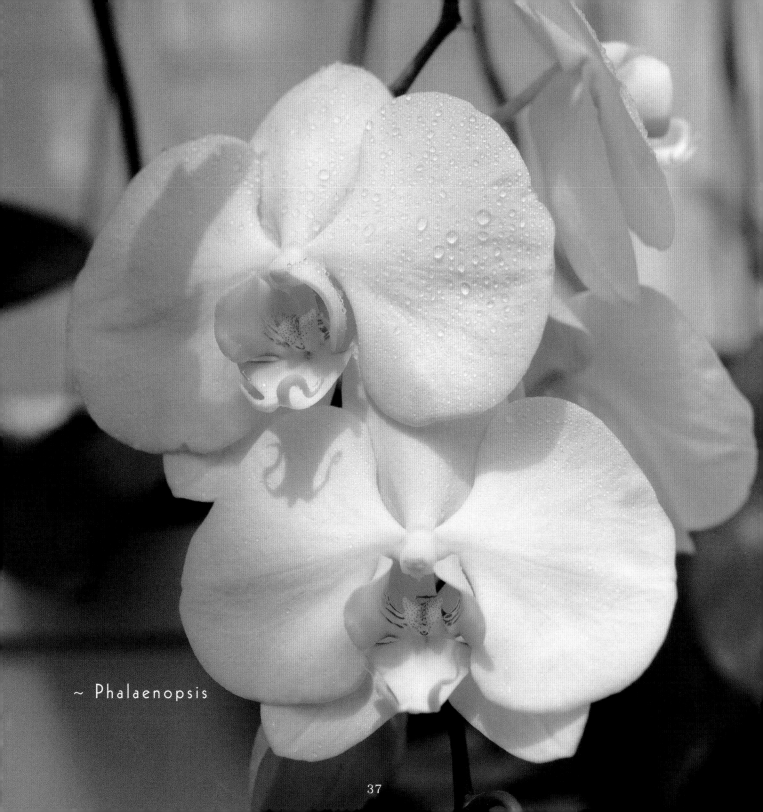

~ Phalaenopsis

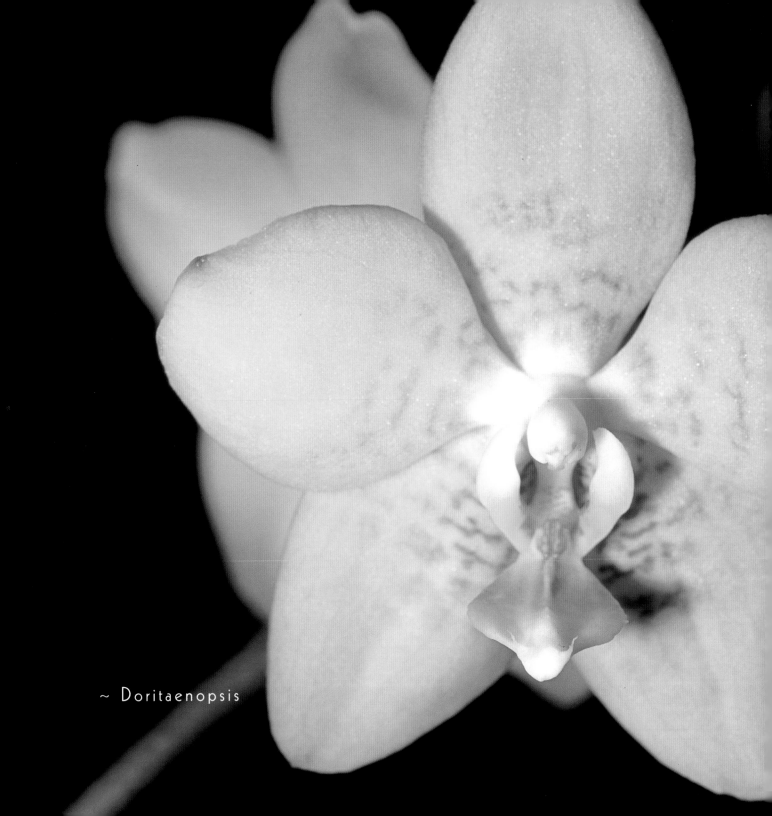

~ Doritaenopsis

Happiness is neither virtue nor pleasure nor
this thing nor that but simply growth,
We are happy when we are growing.

~William Butler Yeats (1865–1939)
Irish poet and dramatist

We know what we are,
but know not what we may be.

~William Shakespeare (1564–1616)
English dramatist and poet

All growth depends upon activity.

There is no development physically or intellectually

without effort, and effort means work.

~Calvin Coolidge (1872–1933)
American president

Now I see the secret

of the making of the best persons.

It is to grow in the open air

and to eat and sleep with the earth.

~Walt Whitman (1819–1892)
American poet

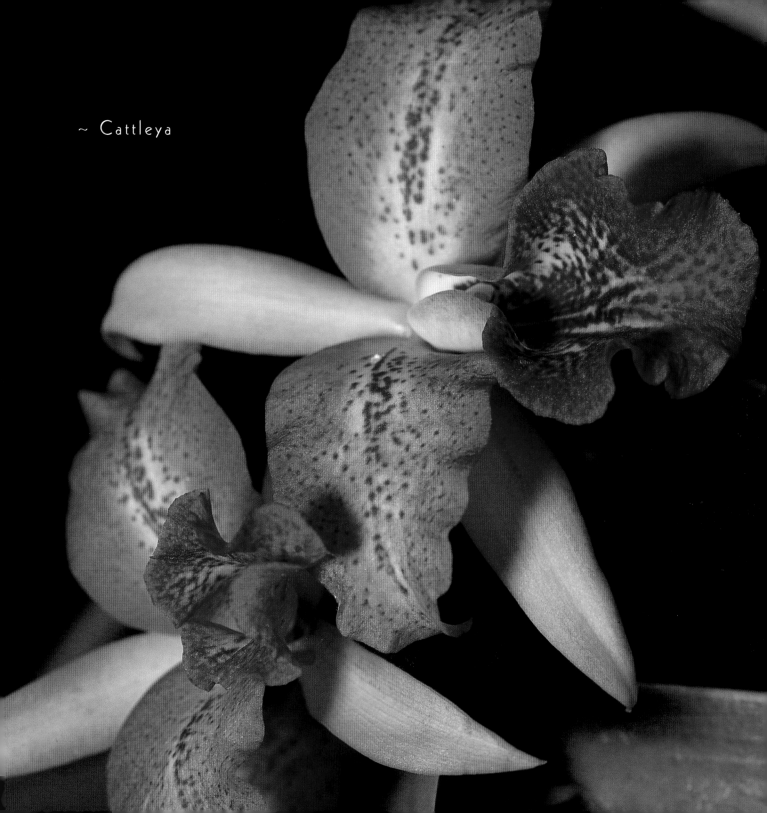

~ Cattleya

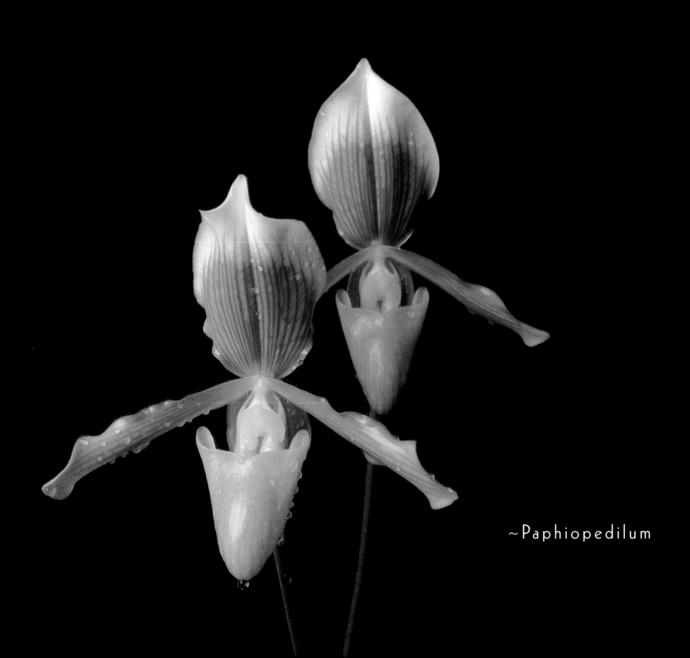

~Paphiopedilum

It takes courage to grow up and turn out

to be who you really are.

~e.e.Cummings (1894–1962)
American poet

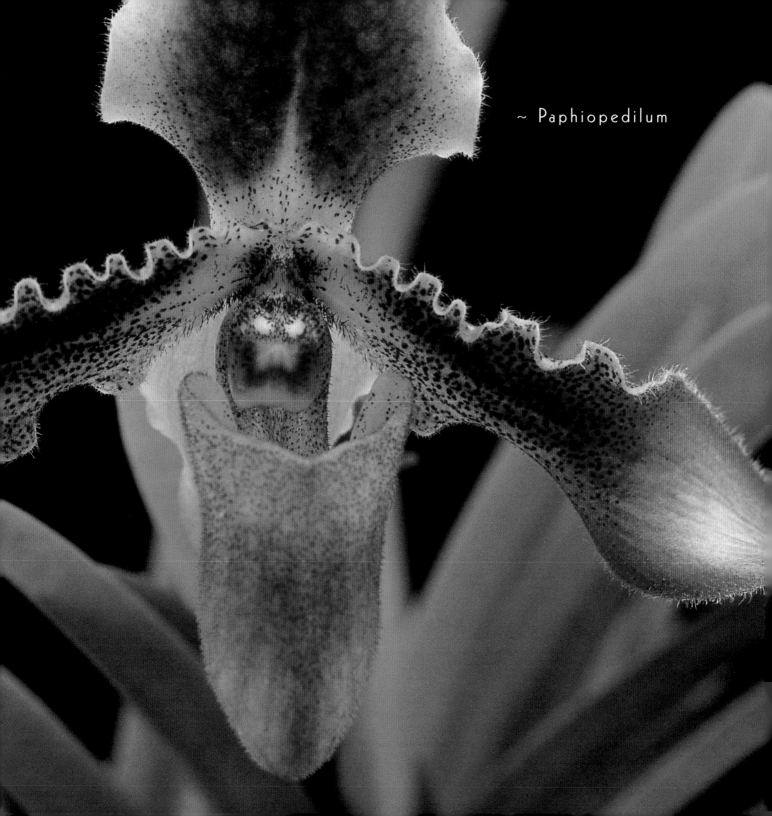

~ Paphiopedilum

grace

~ Cymbidium ~

Gracefulness has been defined to be

the outward expression of the inward

harmony of the soul.

~William Hazlitt (1778–1830)
English essayist

Your vision will become clear only when you look into your heart…Who looks outside, dreams. Who looks inside, awakens.

~Carl Gustav Jung (1875–1961)
Swiss psychiatrist, founder of psychology

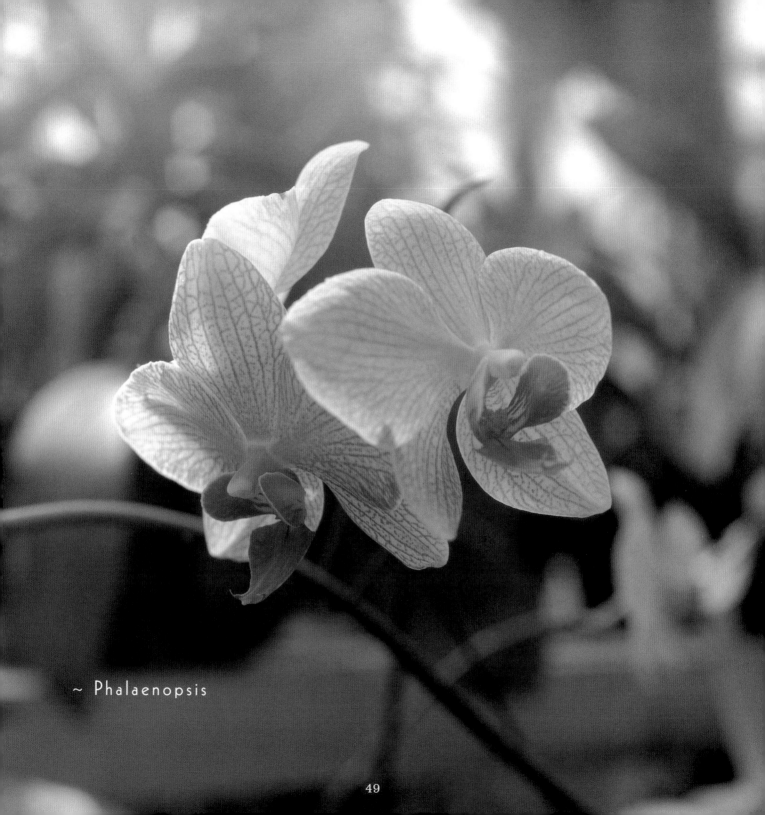

~ Phalaenopsis

Grace is but glory begun,

and glory is but grace perfected.

~Jonathan Edwards (1745–1801)
American theologian

He who lives in harmony with himself

lives in harmony with the universe.

~Marcus Aurelius (121–180 A.D.)
Roman emperor

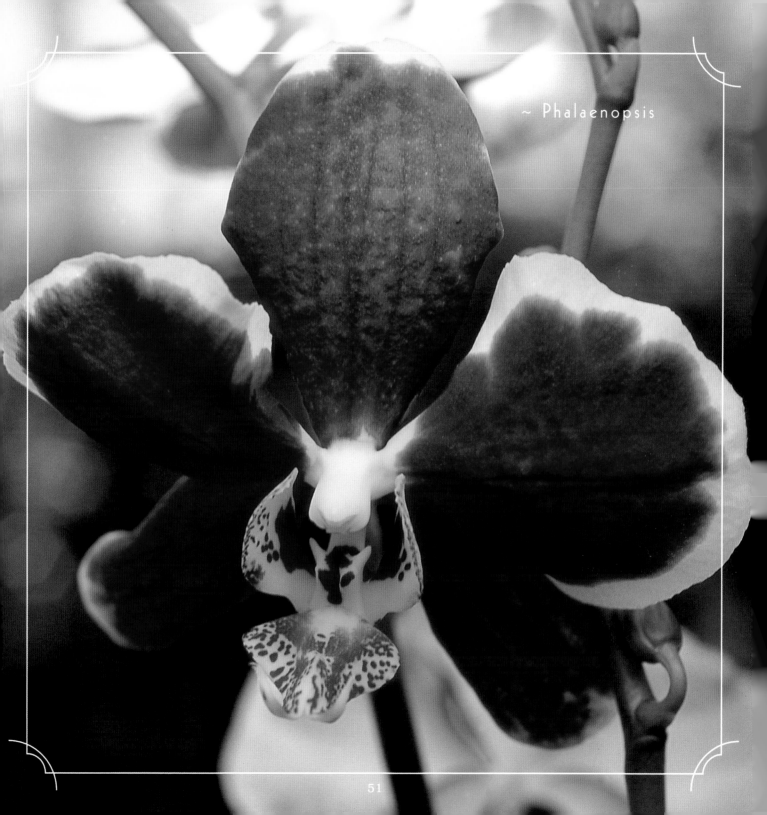

~ Phalaenopsis

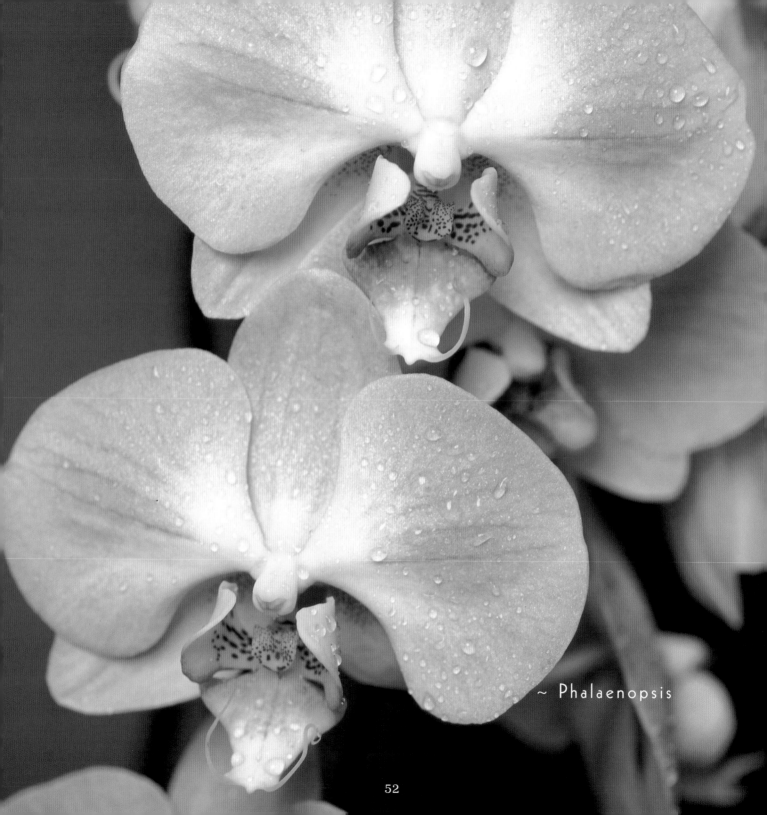

~ Phalaenopsis

Courage is grace under pressure.

~Ernest Hemingway (1899–1961)
American novelist and short-story writer

Learn to... be what you are, and learn to resign
with a good grace all that you are not.

~Henri Frederic Amiel (1821–1881)
Swiss writer

Rain is grace; rain is the sky condescending
to the earth; without rain, there would be no life.

~John Updike (b. 1932)
American writer

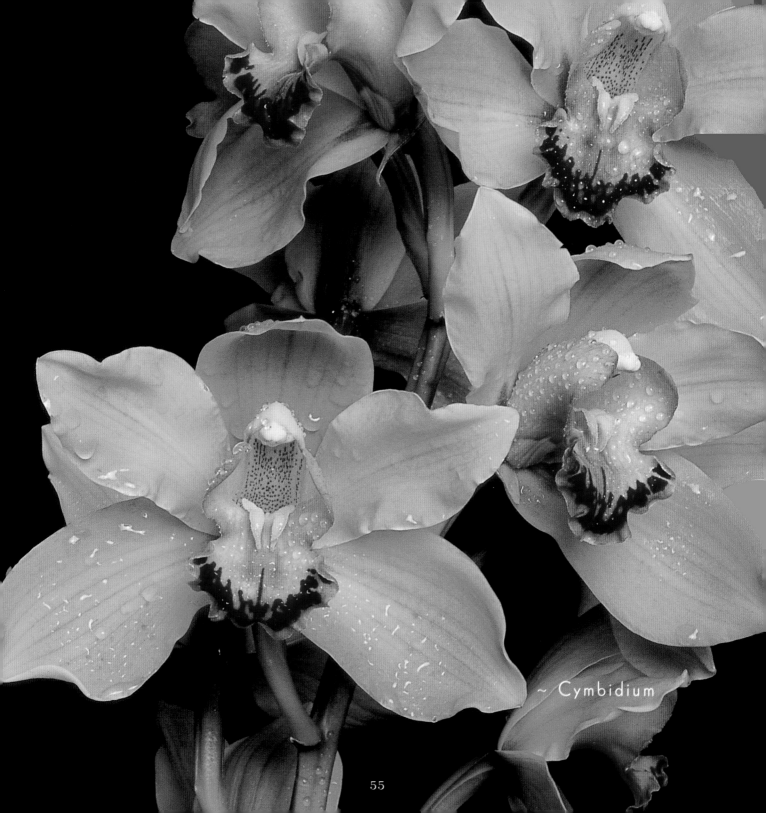

~ Cymbidium

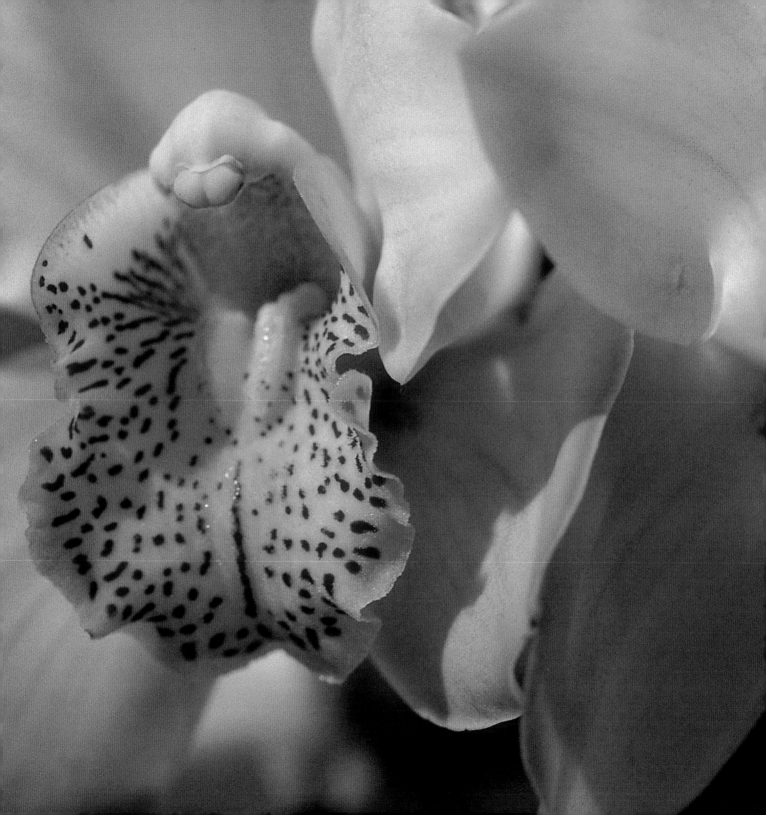

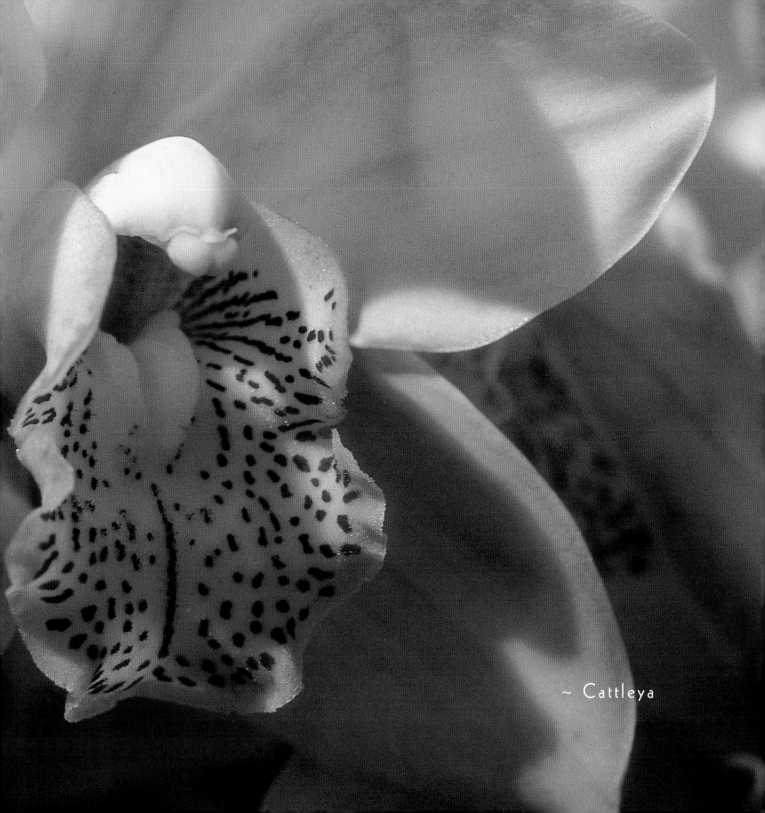

~ Cattleya

The ideal man bears the accidents
of life with dignity and grace,
making the best of circumstances.

~Aristotle (384–322 B.C.)
Greek philosopher

In the midst of movement and chaos,
keep stillness inside of you.

~Deepak Chopra (b. 1947)
Indian-born physician and author

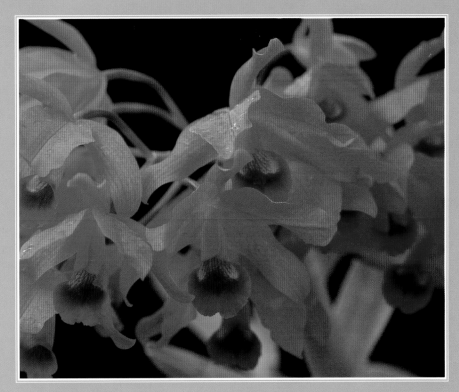

~ Phalaenopsis ~

Experiencing the present purely is being

empty and hollow; you catch grace

as a man fills his cup under a waterfall.

~Annie Dillard (b. 1945)
American author

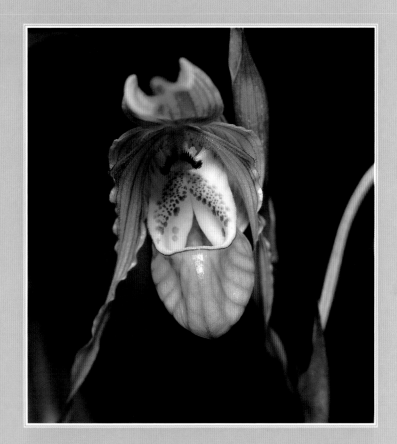

~ Phragmipedium ~

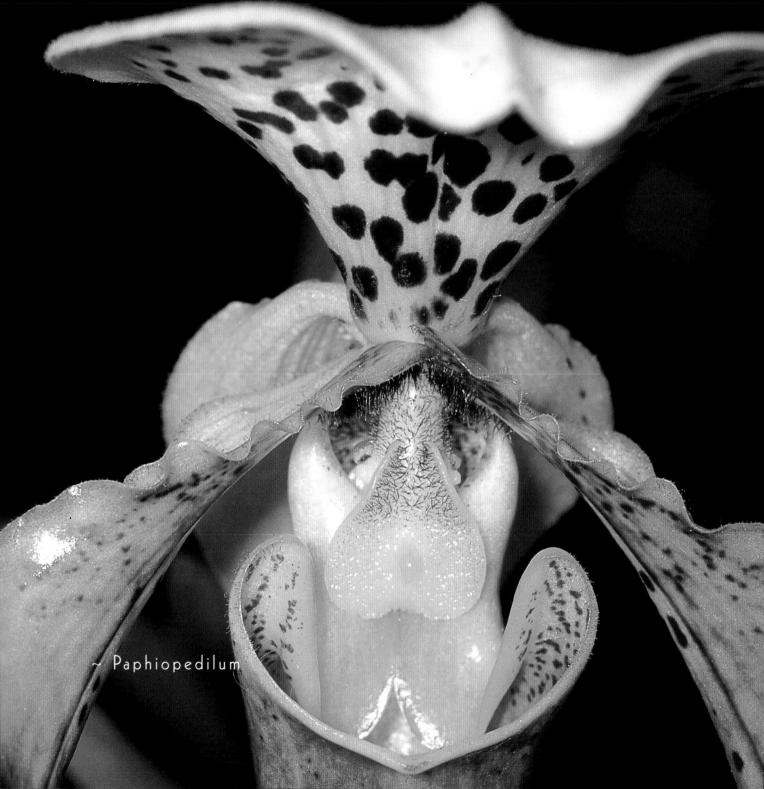

~ Paphiopedilum

strength

Nothing is so strong as gentleness;

nothing is so gentle as real strength.

~Saint Francis de Sales (1567–1622)
French Roman Catholic preacher

~ Phalaenopsis

Our greatest glory is not in never failing,

but in rising up every time we fall.

~Ralph Waldo Emerson (1803–1882)
American writer, poet, and philosopher

Everyone has talent.

What is rare is the courage to follow the talent to

the dark place where it leads.

~Erica Jong (b. 1942)
American author and educator

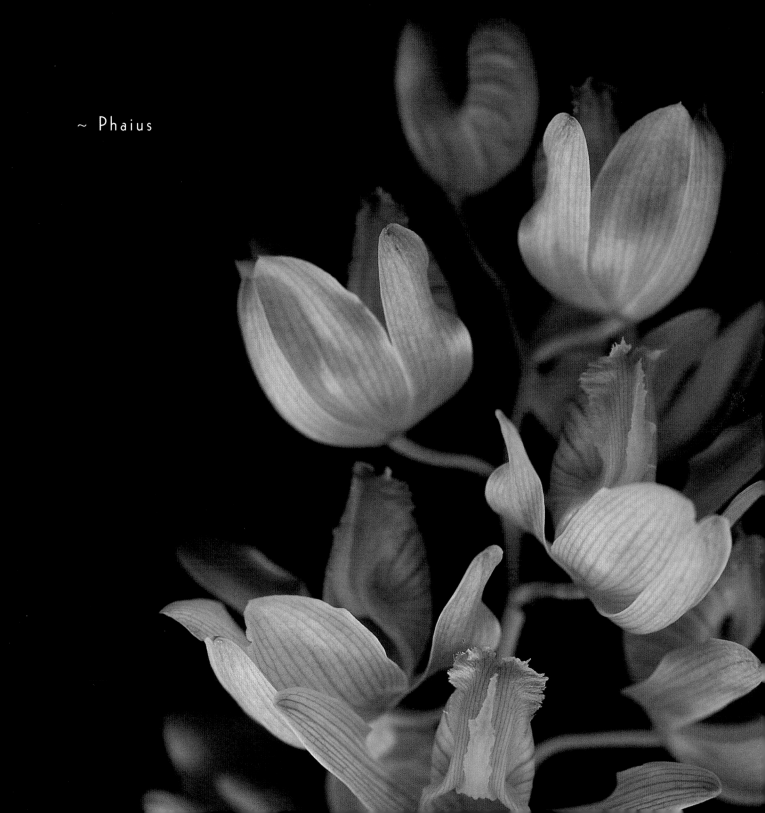

~ Phaius

My strength is the strength of ten,

because my heart is pure.

~Alfred Lord Tennyson (1809–1892)
English poet

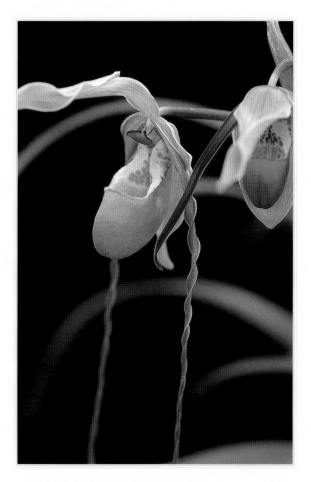

~ Phragmipedium ~

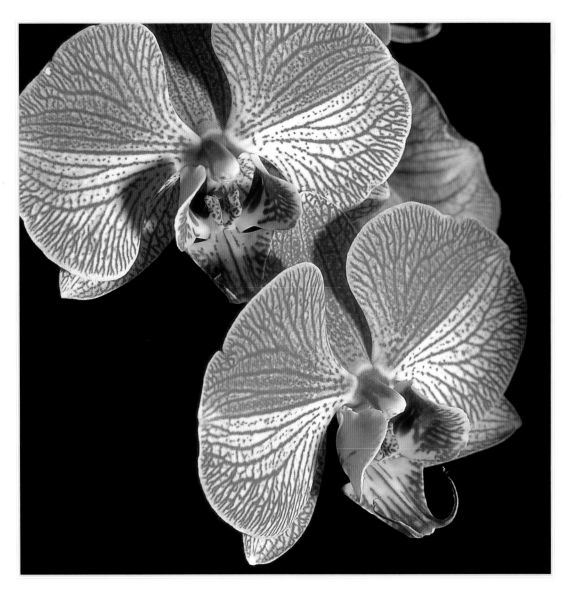

~ Phalaenopsis ~

Character cannot be developed in ease and quiet.

Only through experiences of trial and suffering

can the soul be strengthened, vision cleared,

ambition inspired, and success achieved.

~Helen Keller (1880–1968)
American memoirist and lecturer

To love someone deeply gives you strength.
Being loved by someone deeply gives you courage.

~Lao-Tzu (6th century B.C.)
Chinese philosopher

~ Oncidium

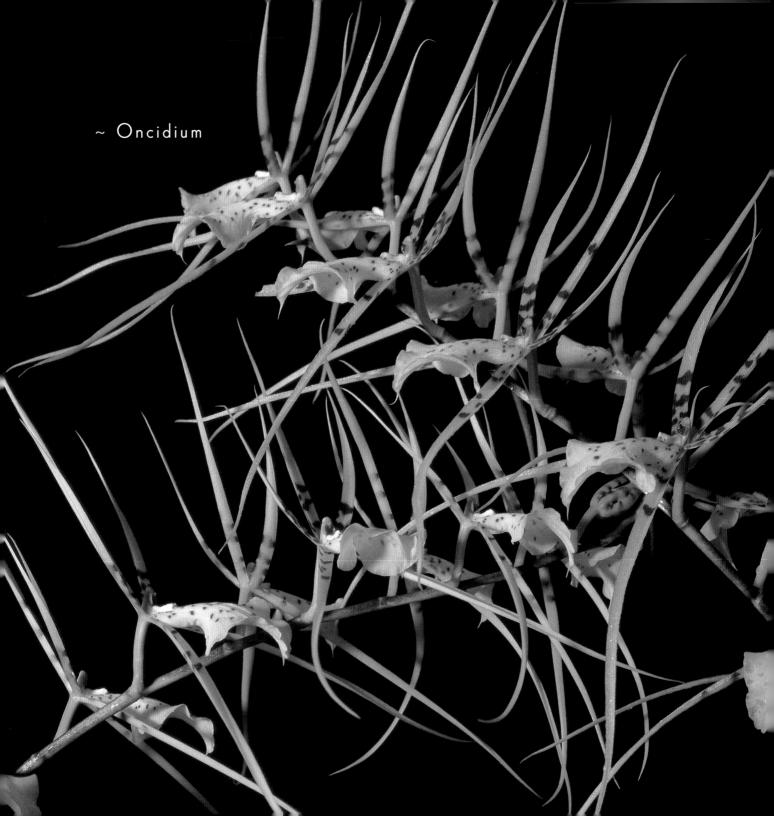

Strength does not come from physical capacity.
It comes from an indomitable will.

~Mohandas Gandhi (1869–1948)
Indian leader

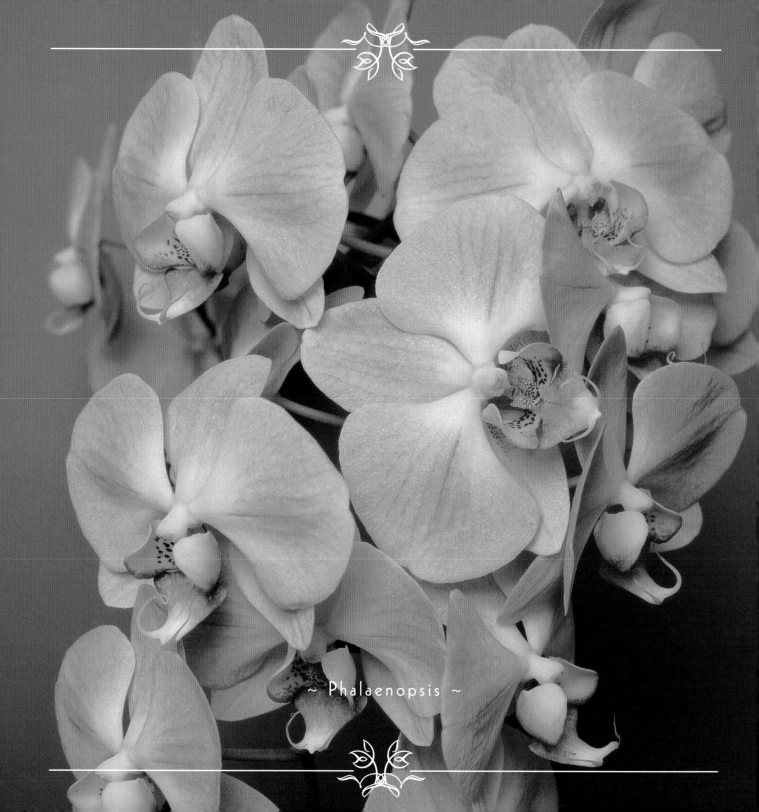

~ Phalaenopsis ~

Beyond talent lie all the usual words: discipline,

love, luck~but, most of all, endurance.

~James Arthur Baldwin (1924–1987)
American writer and critic

Tenderness and kindness are not signs of

weakness and despair, but manifestations

of strength and resolution.

~Kahlil Gibran (1883–1931)
Lebanese-born American mystic poet and painter

The man who is swimming against the stream

knows the strength of it.

~Woodrow Wilson (1856–1924)
American president

Love many things, for therein lies the true

strength, and whosoever loves much performs

much, and can accomplish much, and what is

done in love is done well.

~Vincent Van Gogh (1853–1890)
Dutch postimpressionist painter

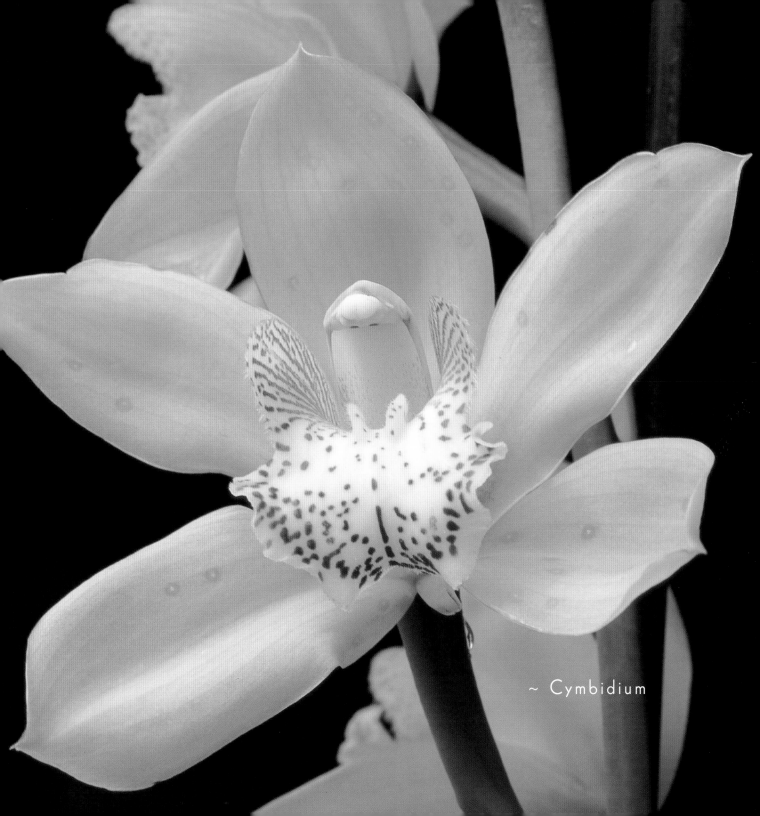

~ Cymbidium

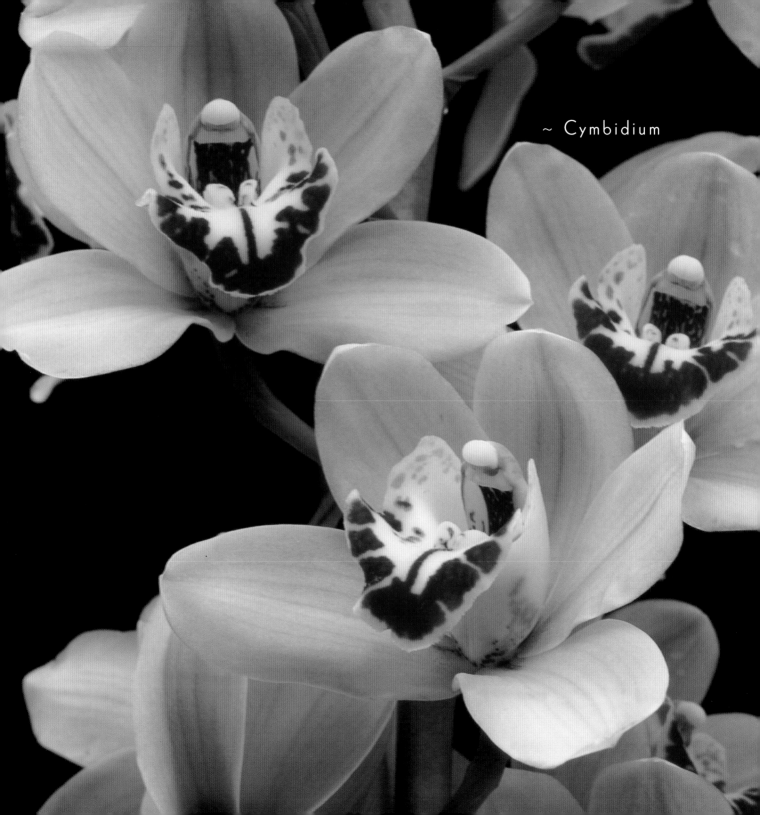

~ Cymbidium

beauty

The most beautiful and most profound
emotion we can experience is the sensation
of the mystical. It is the sower of all true science.
So to whom this emotion is a stranger, who
can no longer wonder and stand rapt in awe,
is as good as dead.

~Albert Einstein (1879–1955)
German-born American theoretical physicist

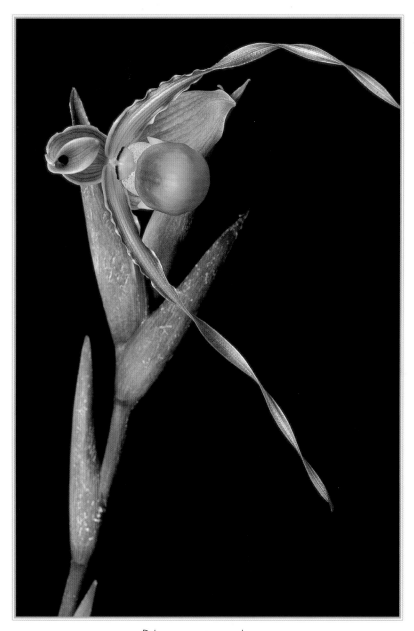

~ Phragmipedium ~

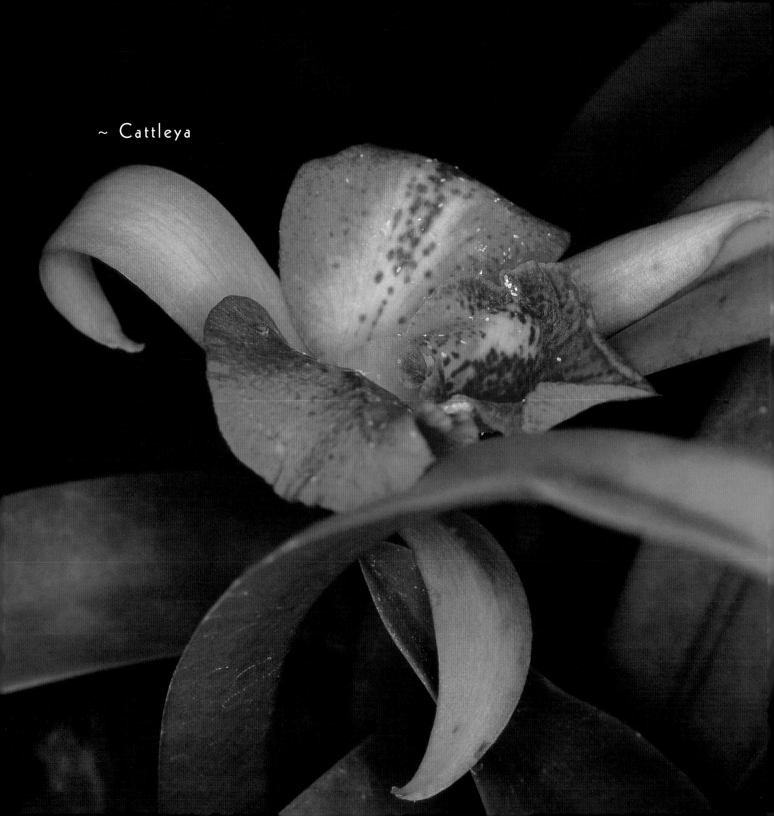

~ Cattleya

A thing of beauty is a joy forever; its loveliness increases; it will never pass into nothingness.

~John Keats (1795–1821)
English poet

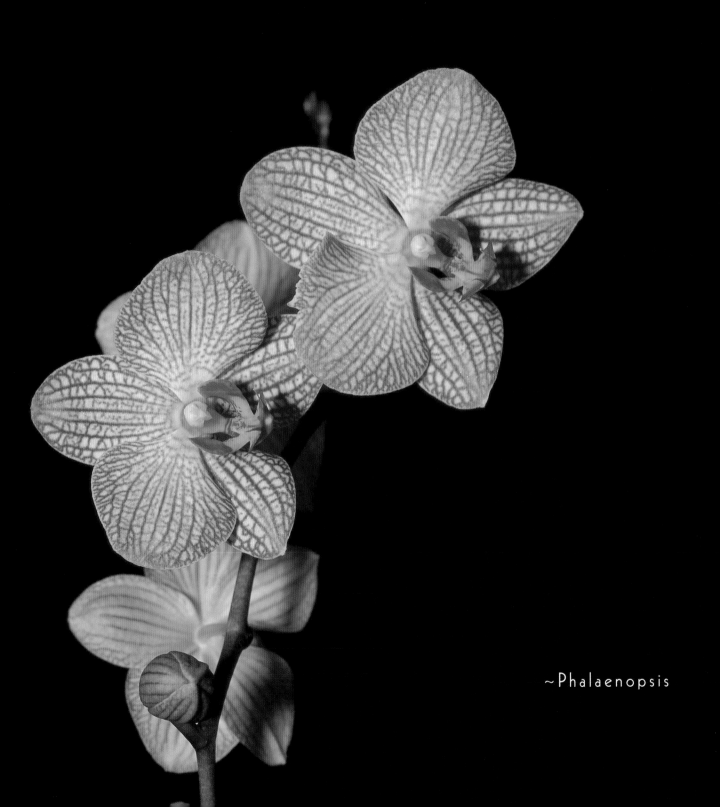

~Phalaenopsis

Art is the unceasing effort to compete with the
beauty of flowers~and never succeeding.

~Marc Chagall (1887–1985)
Russian-born French artist and writer

Beauty of whatever kind, in its supreme develop-
ment, invariably excites the sensitive soul to tears.

~Edgar Allen Poe (1809–1849)
American author

When you take a flower in your hand and really look at it, it's your world for the moment.

~Georgia O'Keeffe (1887–1986)
American painter

~ Cattleya

Give me beauty in the inward soul;

may the outward and inward man be at one.

~Socrates (c. 470–399 B.C.)
Greek philosopher

Y ou cannot perceive beauty

but with a serene mind.

~Henry David Thoreau (1817–1862)
American author, philosopher, and naturalist

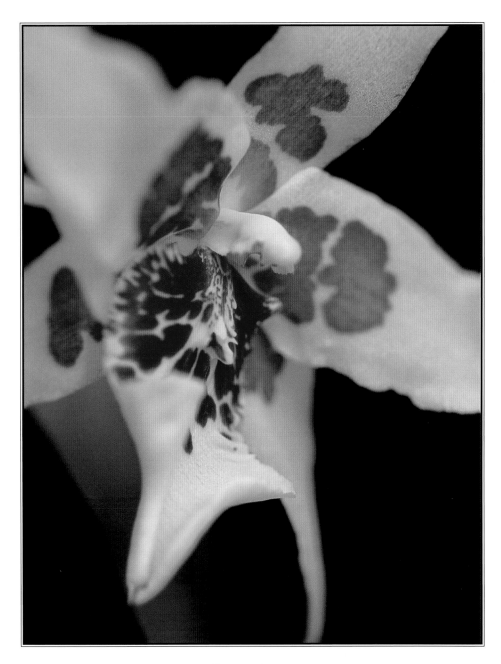

~ Oncidium ~

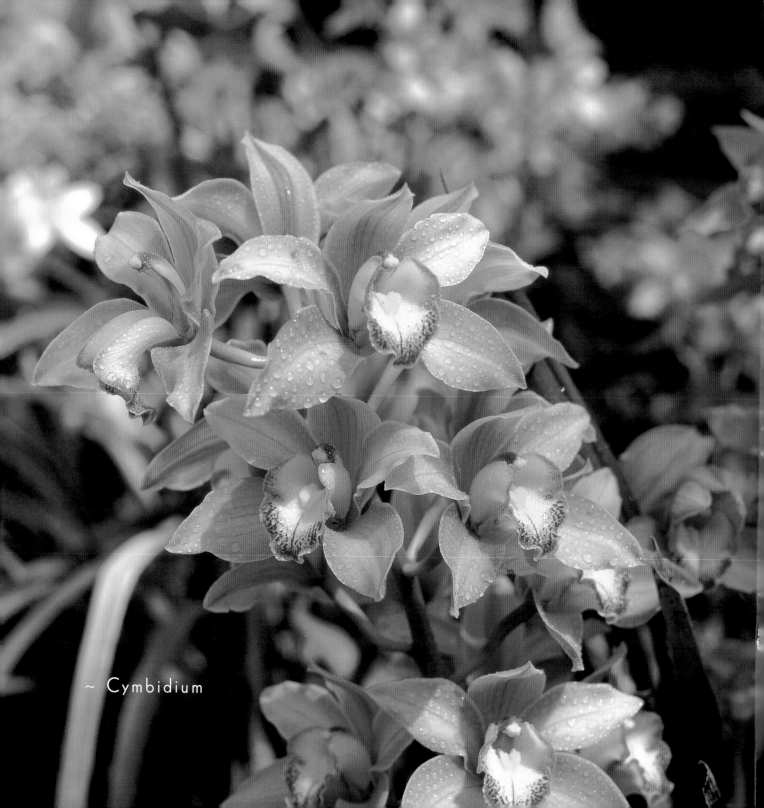

~ Cymbidium

The future belongs to those who believe in the beauty of their dreams.

~Eleanor Roosevelt (1844–1962)
American humanitarian and first lady

There is no excellent beauty that hath not some strangeness in the proportion.

~Sir Francis Bacon (1561–1626)
English essayist and philosopher

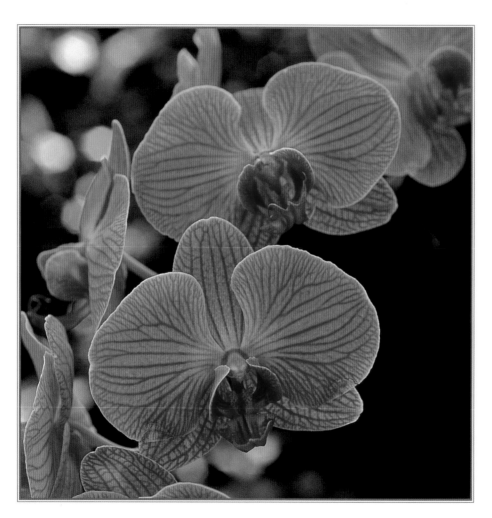

~ Phalaenopsis ~

Beauty is a form of genius~is higher,

indeed, than genius, as it needs no explanation.

It is of the great facts in the world like sunlight,

or springtime, or the reflection in dark water

of that silver shell we call the moon.

~Oscar Wilde (1854–1900)
Irish author

Beauty is in the eye of the beholder.

~Margaret Wolfe Hungerford (1855–1897)
Irish novelist

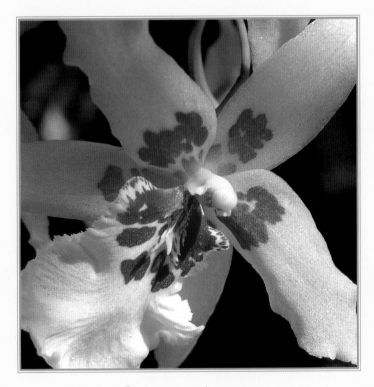

~ Odontoglossum ~